MY DAY
IN SMALL
DRAWINGS

First published in 2021 by Leaping Hare Press an imprint of The Quarto Group

The Old Brewery, 6 Blundell Street London, N7 9BH, United Kingdom T (0)20 7700 6700 www.QuartoKnows.com

Text and illustrations © 2021 Matilda Tristram

A catalogue record for this book is available from the British Library.

ISBN 978-0-7112-6616-2
Ebook ISBN 978-0-7112-6617-9

10 9 8 7 6 5 4 3 2 1

Commissioning editor Monica Perdoni
Cover and interior illustrations by Matilda Tristram
Design by Nikki Ellis

Printed in China

MY DAY IN SMALL DRAWINGS

Write. Draw. Reflect.

Matilda Tristram

CONTENTS

ME / MY HOME 22

THE WORLD AROUND YOU 76

WHY COMICS?

Why write comics rather than a 'normal' book? This is a question that comic artists are asked all the time. Comics are an incredible, unique art form. You can tell stories in any direction, leading the reader's gaze across the page in any way you like – left, right, up, down – depending on the way you lay out your drawings. Time works differently, too, when you're reading a comic; a picture communicates meaning in an instant, and can transmit a profound sense of those thoughts and feelings that are hard to describe with words. You can break up the page however you choose, using differently sized frames to affect your narrative, or not break it up at all and tell a whole story in one image.

Text can change the meaning of an image and vice versa. It's like magic when this happens. If you draw something happy, then next to it write something sad, the essence of the whole thing is heightened. There's irony, and you realize there is sadness in happy times. If you draw something ordinary or mundane then write something weighty next to it, suddenly those small, everyday things hold a greater significance. You can create your own visual language and tell stories in a way that's uniquely yours.

Anyone can write fantastic, impactful comics. You don't need to be brilliant at writing or drawing; you just need a pen or pencil and something to write about. This book is a way in; it's about starting small, creating short narratives, and using dialogue and images to build a scene. It's about getting past the idea of writing something epic and just starting to write. Your style will develop as you go.

DIARY COMICS

I started writing diary comics and posting them online to inform people about my experience of illness and disability, caused by a cancer diagnosis during my first pregnancy (my son is fine now, and so am I).

Sharing my comics really helped me to feel less alone in that experience: other cancer patients and supportive readers got in touch to cheer me on, and I was able to let people know how I was feeling, how treatment was progressing, and what they could do to help, without having to have the same upsetting conversations over and over again. I could educate people about which symptoms to look out for. I could give healthcare workers a better understanding of what it was like to be a patient by drawing those exchanges that made me feel well cared for and treated like an equal, and the few interactions that left me feeling baffled, dehumanized or not taken seriously. I could discuss the problematic ways that cancer patients and pregnant women are spoken to and talked about. It gave me something to do during long stints in hospital. There was suspense, tension, grief, fear, and those things made for a great 'story', although it was actually my life!

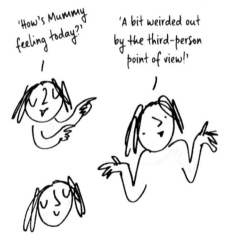

Once you decide to keep a diary, and to pay close attention to people and things in order to write about them, it feels like you're permanently at the theatre. Fascinating and funny characters come and go the whole time; when I was in hospital, there were kind, charismatic doctors and nurses; chatty porters; and very old patients talking about their amazing lives (fudge, fags and running for the bus is the secret to longevity, apparently). You could take inspiration from anyone you know, happen to meet, or that you remember.

During the COVID pandemic, writing comics helped to pass the time when we were all locked down at home. Looking back at how we coped, at joyful times, at things that made me laugh, helps to shake off the anxiety and gloom of the past year.

Comics about ordinary life and 'small' things can be just as moving, poignant and meaningful as comics about crises or life-changing events. Everyday moments are relatable and can grab a reader who recognizes those situations that you describe.

So, there are lots of good reasons to write diary comics: to educate and inform; for their therapeutic value; to connect with people; to kickstart conversations that you want to have; and, most importantly, because it's fun.

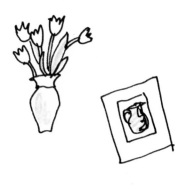

DIARY COMICS AS A THERAPEUTIC ACTIVITY

When I'm concentrating on how to describe or draw something, I stop thinking about how I'm feeling. I start enjoying making artistic and narrative choices and creating something new. It also feels emotionally beneficial to put my thoughts in order and 'get them out' on paper, to acknowledge the things that I'm worried about.

At the same time, I sometimes feel annoyed by the suggestion that artists make diary comics simply because it's therapeutic or cathartic. It seems reductive, as if we are just doing it to feel better, rather than creating Great Works of Art.

But artistic value and therapeutic value are not mutually exclusive. Diary comics are an incredibly rich, varied, experimental, complex, political art form that can tell us so much about people and society. And the therapeutic aspect of diary comics makes them even more valuable; when modern existence is uncertain and scary, it's a bonus to be made to feel better.

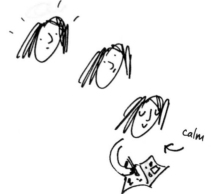

calm

THE COMICS COMMUNITY

I love the comics community. It's so great to post a strip online and receive encouraging feedback from people who have enjoyed it. I've come across so many brilliant artists online over the past few years by engaging in this way.

I particularly love web comics because the form lends itself to work that exists for the sake of the idea, and for the sake of telling a story or connecting with a community; commerciality isn't always a concern, and that's exciting. Creating comics for fun, for yourself, gives you a certain freedom: you can be weird and experimental, or write about subjects that fall outside of the mainstream. Saying that, web comics and self-published material frequently cross over into the mainstream eventually because they are so good!

Lots of popular comics, graphic novels and animation started online, and fans helped the material reach a wider audience, and the artist to thrive.

If you're a visual artist of any kind, making comics is a great way to test your ideas. To think about structure and dialogue, and to practise visual storytelling.

JOURNALISM & MEMOIR

Comics are engaging and accessible. You can draw people in with a compelling image, with an informal tone or writing style, with your personality, or with a joke (if appropriate), then make your point when you have your reader's attention.

Because of this, comics journalism (first-person experiences, eyewitness reportage or interviews in comic form) can be a powerful tool when it comes to describing complex or political situations. The comic form can help a reader relate to a story. You see an expression on a face and appreciate what that person is feeling. You see a drawing of their home, clothes or possessions and recognize that they are just like you. You hear their voice in the conversational dialogue and feel that you know them. You notice an artist's drawing style and understand something of the physical circumstances that led them to draw in this way, with those materials. When we are so used to seeing photographic images of conflict, it's useful to be able to present these stories in a different format.

With memoir, you get to know history, humanity and society through the author, their friends, their family, their experiences and their lives.

Diary comics can give a voice to writers who are marginalized for any reason. They cost very little to do. You don't need any expensive equipment or a studio space, just the desire to write about your own life and thoughts.

HUMOUR

How do you make something funny in a comic? Real life is funny. Sometimes you don't need to do anything more than describe what actually happened. Think about how many frames you need to make the comedy work. What will you give away to begin with? What will you save up for the end? Will there be a reveal or a punchline? I don't mean like the punchline of a joke, but one final image that makes all the others make sense, allows you to see the whole thing differently, or is the funniest thing that you have saved until last.

Humour in comics can also come from stretching reality in a drawing, by exaggerating events or making up absurd or surreal narrative elements: a person suddenly walking on the ceiling, an object speaking to you. Sometimes it comes from a surprise, events turning out differently to how you thought they would, like a relaxing trip to the park being interrupted by an annoying leaf blower. Or a visit to a petting farm where you intended to stroke cute guinea-pigs but ended up tickling the tummy of a giant hissing cockroach.

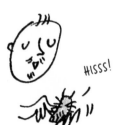

I was asked recently why I think humour is important, and whether I think we need jokes in order to get through difficult times. I think humour is unavoidable. Life is difficult and funny. You have no choice but to get through life, because you are alive, and you will laugh at things while you are doing this because you are a human. People are funny, we respond to funny things, and we want and need to laugh.

Cracking a joke can sometimes feel like a kneejerk reaction, to put people at ease. Yet I also think it's important to sit with emotional pain, sadness, fear, disappointment, if it's there, and not feel pressured to be funny. You don't need to look after your reader or make sure that they're enjoying themselves. You can be serious and sincere. Honesty is engaging, too.

Saying that, I love making people laugh. It's the best feeling. And writing diary comics feels like a good way to practise – how can I make this as funny as it can be?

'hey...is this funny?'

'kinda'

VISUAL STYLE

Try not to think too much about what your comics look like, just see what comes out. A drawing doesn't need to have taken ages, to look realistic or be full of detail to communicate meaning: rough, scrappy and pared-back drawings can do this, too.

The more you draw, the more comfortable you will become with the process, and a style will develop that feels uniquely yours. I often do several versions of a drawing before I am happy with it. And gone-wrong drawings can be really funny and worth keeping! If you want to, you could practise working on separate pieces of paper and stick any that you like into this book.

Different line qualities and choices of material can say something about how you're feeling when you make a drawing: confident and bold, upset and wobbly, excited and all-over-the-place.

Working out your own visual language is brilliant fun. If you're drawing a person, think about the shapes or marks that would best describe them. What do they really look like? Do they have a long head or a round one? Close-together eyes or far apart? How simple can you make the drawing? I give myself the same scribble of hair in every drawing; my hair doesn't actually look like that – it's so you can always identify which character is me.

If you don't feel like drawing people, you could use abstract shapes to represent characters instead. A felt tip blob or cut-out shape could speak, just like a person might.

TEXT AND IMAGE

Think about how your writing relates to the picture, how it fits around your drawings and becomes part of the image. Where will you arrange the text so it can be easily read and understood? A caption underneath the drawing? Or scattered around the composition? If you're writing a conversation, put the character that speaks first to the left of any other characters, so their dialogue will be read first (because we read from left to right).

Your writing can be as expressive, visually, as your drawings. My handwriting has been typeset in this book to ensure that it's legible, but in my original comics the way that I write changes depending on the mood of the drawing. If I'm shouting, my writing is larger and often in capitals. Think about whether or not you want to do this.

SPEECH BUBBLES

If you use speech bubbles, do the writing first so that you know how big the bubble needs to be. It's frustrating to draw a speech bubble then find that your text doesn't fit into it. You can have fun with the shape of speech bubbles too: make them spiky or jagged for angry speech, smooth or soft-edged for ordinary conversation.

I don't usually use speech bubbles because I don't tend to put anything in the background of my drawings that would make any text hard to read. I prefer to just let my writing fall around the drawings in whatever arrangement feels comfortable.

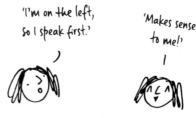

WRITING STYLE

Don't worry about having your own writing style, or about having something important to say. Your observations and ideas will be worthwhile because they are your observations and ideas. Write a lot, write about stuff that feels insignificant, write about the same thing over and over again if you want to.

Think of every strip as an experiment and see how it goes. You don't have to write in complete sentences. You can just use dialogue if you want to. You can describe sound-effects with made-up words.

You may find that your narratives change as you draw, because looking at an image prompts different ideas to those you might come up with when looking at text.

Once you get in the habit of writing a diary, you will notice more: things will strike you as significant in a way that they didn't before. By working out how to describe a scene you will remember moments and conversations in greater detail, and images with more clarity.

'Don't worry, I've written it down so we can remember everything for ever and ever and EVER.'

PENS & PAPER

Fineliners are my go-to choice of pen for diary comics (the Pigma Micron 05 is my favourite at the moment). The lines are clear and the marks consistent and easy to control. I want my comics to be read easily, and I want to be able to do them quickly, so fineliner pens are ideal. You might want to use something that gives you a bit more variation in the marks that you can make, like a soft pencil sharpened to a point, or ink and a dip pen.

If you want to add colour to your work, try out different materials and see what you like. It's worth sourcing good-quality colouring pencils if you can, like Faber-Castell or Caran d'Ache. You don't need a whole set, just a few colours. Or you could use cut-out paper to create different colours and textures, and draw on top of the shapes to turn them into objects or characters. Think about which marks you need your reader to see

in order for them to understand the drawing. You don't want to create a beautiful comic with a fine pencil then colour it in with a huge felt-tip so that your original image disappears.

I prefer drawing on paper to drawing digitally. I like the feeling of ink going onto the page, and the fact that I can't correct everything. For diary comics, I use A5 plain newsprint notebooks. I buy about 20 at a time from Muji. Because they are so cheap, I don't worry about using up lots of pages on getting a drawing right. They are small and light enough to carry around, and the paper is smooth and doesn't have any texture that would interrupt the pen marks.

CREATING A CHARACTER

If you write diary comics, you invent a version of yourself. What kind of character will you create? What will you do with them? Is there something that they can say that you can't? Are they like the real you or slightly different?

The character that you see in my comics is a version of me, but she isn't really me. She starts conversations that I want to have, she swears more than I do, and she says the funny things that I only think of in real life when the moment has passed. Will there be a time when I no longer need the comic version of me? Will I change while she stays the same? Or will she change with me? I draw myself, but you don't have to. You could draw from your point of view, rather than putting yourself in the strip.

A diary isn't just a list of things that have happened. It's a constructed world. It doesn't all even have to be true. You decide what to include or leave out. You have control over the narrative and stories that you want to tell, about yourself, about anything.

It's interesting to see which of my comics appeal to people. Any strips that share personal moments seem to strike a chord. It's tempting to respond to that by sharing more and going deeper, but I don't think that's healthy. I try to write for myself, and that works fine.

THE PEOPLE IN YOUR LIFE

If you plan to share your comics,
think about how you portray the
people in your life. How will they
feel about what you are writing?
Ask whether they are happy for
you to share a comic in which they
appear. If you want to write about
someone without revealing who
they are, you can anonymize them
by changing their appearance,
leaving them out of the frame, or
by adjusting other narrative details.

HOW TO USE THIS BOOK

The 52 sections in the book can be completed in any order. Start with a prompt that appeals to you. If you find any subject particularly inspiring, do continue with it outside of this book.

Or you might find that some of the starter subjects don't appeal as much, in which case use those sections to continue with other narratives that you are enjoying. You could ignore the frames provided and divide your pages differently, if you like, with smaller or larger boxes. It will be a record of your life that grows with you.

As I got further into writing and drawing this book, I noticed my drawings improving. It's tempting to start again at the beginning and redo the whole thing – but that's just what happens with drawing, and with any kind of creative art: the way you work will always develop and change.

WRITING ROUTINE

If you can and want to write every day, great. But don't feel pressured to stick to a routine if it isn't something you can manage. Write when you feel like it, so it doesn't become another chore.

For a while, I tried to write a diary comic every day, to see if I could. I managed it for almost a year, then I started to find that the pressure to post made it a bit less enjoyable, and the temptation to sit refreshing for 'likes' for hours after I posted each strip got a bit much, too.

Now, I go through phases of writing comics every day, then there are times when I don't write anything for a few weeks. I don't worry about that; more ideas always materialize. Once you start looking really closely at life, and you get to a point where you're enjoying working out what you think about it all, writing will start to feel easy.

Not writing

ME / MY HOME

Take inspiration from yourself and your immediate surroundings, from everyday rituals, activities or spaces, to objects or garments that mean something to you. Enjoy thinking about how each experience or thing makes you feel and write those fragments down.

IF OBJECTS COULD SPEAK

I've got this orange cardigan that always snags – on
door handles, on my bike in the corridor, on a nail
in the wall. I imagined that these objects all had
something urgent to say to me. If the things in your
house could speak, what would they say and how
would you react? What does this reveal about you?

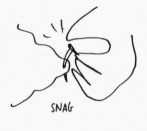

SNAG

'Hello! What can
I do for you?'

'I just wanted to say
that you look nice in
your orange cardigan.'

'Oh, thanks! You look nice
sticking out of the wall.'

'You don't always have
to return a compliment.'

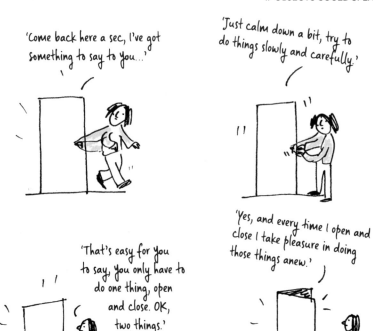

Draw short strips about conversations with objects.
I haven't turned these objects into characters
with faces, but have added dashes and wobbles to
show that they are alive. While you're drawing the
conversation, you might think of other things to add
to the narrative, like the darkness behind the open
door when it tells me to enjoy each moment.

YOUR HOME

Do you have a favourite place within your home?
Mine is in the kitchen by the radiator. In this comic,
I enjoyed trying to fit the entire room into one small
drawing. There are other parts of my home that aren't
so nice, but are fun to write about and draw. Junk piles
up in the corners of rooms. Towels are everywhere. It
feels like they are sentient, slung over doors waiting
to fall on me, so I turned them into groaning beings.

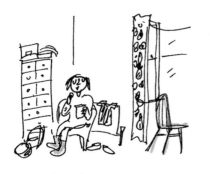

I love sitting in the corner
of the kitchen...

...and eating snacks!

Too many towels around the flat.

Let's stick to no more than three towels
out of the cupboard at any time.

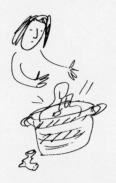

OK?

Write short comics about the relationship that
you have with your home. How do you use each
different area? What memories are attached to
these spaces? Think about how you could make a
room seem characterful. Walls can appear to loom
if you make them tilt inwards. You could distort
shapes, perspectives, angles or viewpoints to
change how an interior space feels in your drawing.

SIGNIFICANT GARMENTS

Do you own or remember garments or outfits that remind you of particular times in your life? Write short strips or single panels about these. Maybe it's an old jumper that's completely worn out but you don't want to throw away. Or something that makes you feel happy or comfortable.

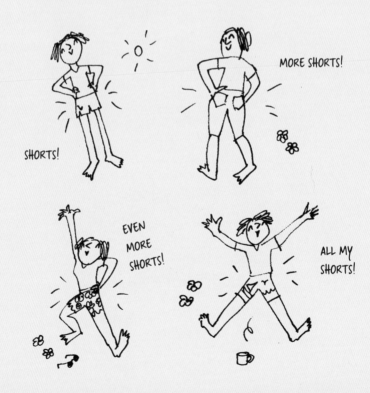

SHORTS!

MORE SHORTS!

EVEN MORE SHORTS!

ALL MY SHORTS!

Superhero jumper!

??? How did he end up on my back?

I loved touching the plastic flowers on my childminder's mantelpiece.

'I'll just do yer chops...'

And the way her Irish accent sounded when she talked about 'chops'.

It could be that you start by drawing a significant garment, then move on to describe the things that it prompts you to think about: like this jumper that my childminder knitted for me in the early 80s when I was about three. Thinking about it reminded me that I used to feel puzzled by the way the picture would always end up on my back, when it had been on the front before I put it on.

CHORES

For a while, I kept note of all the things that I hoovered up. It was an interesting record of life's leftover fragments: a shard of chocolate Easter egg, a small black pompom, a yellow crayon, a Lego bone. I stopped bothering after a while, but still enjoy examining small bits of crud, like things left behind in the rim of the washing machine.

Write strips about clearing, cleaning, sorting, tidying. What does your 'life crud' consist of? Are you sentimental about old stickers, or do you find mess oppressive? You could write about other errands that take you out of your house. If you have a garden, is gardening a chore or not? What do you think about while you complete these tasks? Or what do you find to do instead?

Unclogged the rim of the washing machine

pistachio nut shells, 5p, popcorn kernels

Unblocked the
bathroom sink

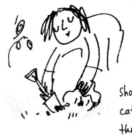

Shovelled up
cat poo in
the garden

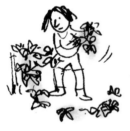

Cleared a load of ivy
from the fence

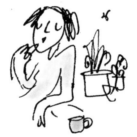

Ate some tahini
and chocolate-chip
biscuits on the
front steps

Will do the bedroom
another time

MUSIC

Over lockdown, my aunt and I met via video call and played the piano together. I attended my first Zoom rave and was able to do my grocery shopping at the same time. Exercise is doable if I'm listening to boshing techno. I thought the combination of abrasive electronic music and gentle yoga stretches was funny. How does music feature in your life? You could write about significant or favourite songs and how they make you feel.

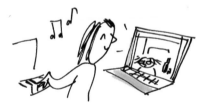

Playing Max Richter pieces with my aunt Polly. We do a page each.

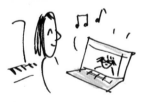

Such a strange and lovely thing to do. I want to cry.

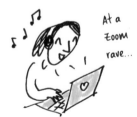

At a Zoom rave...

...doing a food shop.

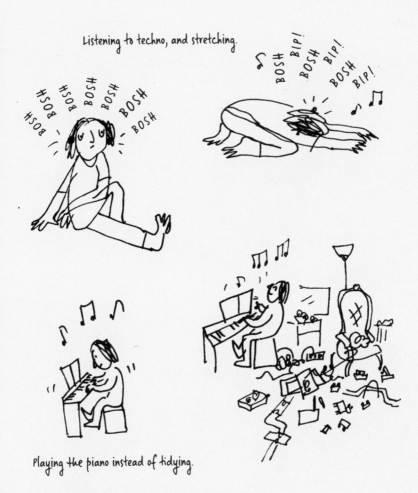

Listening to techno, and stretching.

Playing the piano instead of tidying.

IN THE GARDEN

If you have a garden, sit outside. What's around you in the way of wildlife? What can you hear? If you don't have a garden, sit by a window or find a park or patch of green space. What do you notice? The sudden appearance of this huge bee, so focused and oblivious, is a moment I'm glad to remember.

Watch a bee sucking nectar from flowers on a wild sage plant.

Grabbing the petals and latching on like a baby.

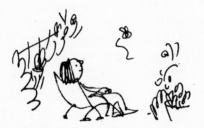

Such a big presence for such a small thing.

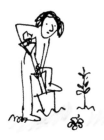

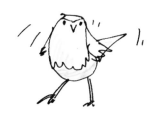

A robin came to see what I was up to.

Planted some bulbs.

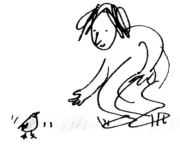

I left out a little pile of oats
for it on top of the bike shed.

It wasn't scared of me at all.

If you can see birds or insects, watch the way they
move. Each creature's different characteristics can
imply a personality. Industrious ants, skittish and
mischievous squirrels, tenacious worms struggling
across wet pathways, risk-averse woodlice. To draw
the robin in this comic, I looked online for a picture to
use as a reference.

MY REFLECTION

I like writing comics about spots, body hair, grey hair and scars because it feels as though I'm resisting narrow beauty ideals that make people feel like they should look a certain way: young, smooth, toned, thin . . . What do you notice when you look in the mirror? What conversation does it start in your mind?

Sometimes, I feel annoyed about still getting spots.

Then I think, 'naaah!' I'll wear them proudly!

In protest against companies selling us crap that we don't need!

Dismantling capitalism one zit at a time!

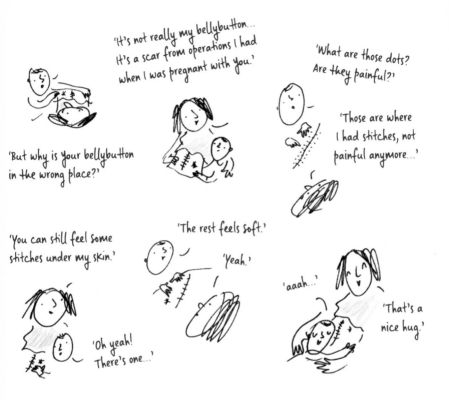

Create strips about your own body. They don't just have to be about your appearance. The comic form is perfect for describing bodily experiences that we don't have words for: the way we react to grief, anxiety, illness, love, excitement. You could write about something significant, like a health problem you experienced, or something less serious, like a time you had something stuck in your teeth.

CREEPY CRAWLIES

How do you feel about spiders? I'm not as frightened of them as I used to be. One ran out of a T-shirt onto my neck, and I noticed as I flung it away that its legs felt sort-of springy, like a tangle of elastic bands. If I catch one in a glass, calling it 'dude' seems to make it less scary.

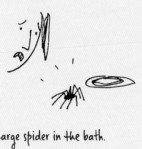

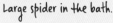
Large spider in the bath.

'Come on, dude, in you go, into the glass...'

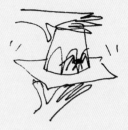

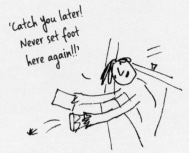
'Catch you later! Never set foot here again!!'

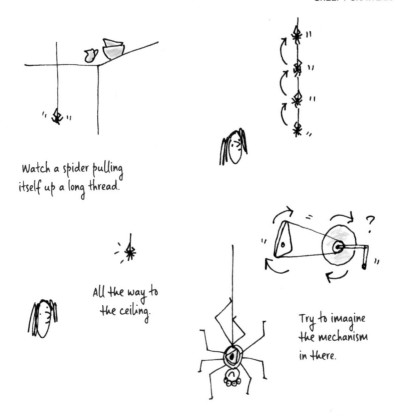

Watch a spider pulling
itself up a long thread.

All the way to
the ceiling.

Try to imagine
the mechanism
in there.

If you see an insect in your home or outside, take
a minute to watch what it is doing. If you were to do a
voiceover for its activity, what would you say? What
tone of voice would you use? What obstacles does
the insect encounter? How does it deal with them?
How would you describe the way that it moves?

ITEMS THAT MAKE ME HAPPY

On a really cold day, drinking tea, I thought about why I love my favourite mugs. I use the cat one most often because it feels nice to hold, and I like thinking about my son having chosen it for me. Sometimes I deep dive honeycomb-glaze pottery for sale on eBay; I love the way the white paint looks like cappuccino foam frothing over the sides.

Do you own any items that you really love? Either to use or to look at? Perhaps the way an item is designed is satisfying, or maybe it works really well. What about heirlooms, gifts or things that hold personal significance? Or you could write about items that you really dislike.

Honeycomb-glaze coffee pot and matching cup.

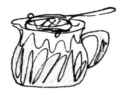

Lovely and shiny, same dark brown as black coffee... dainty and neat, feels so chic!

Cute cat mug, a birthday present, completely smooth...

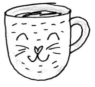

... no corners, nice and chunky, not easily knocked over. LARGE (for tea only).

Tiny black teacup,
a gift from a friend.

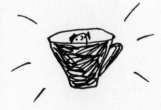

It used to have a drawing of my
face printed on the inside but that
came off in the dishwasher.

One with a strange collage
printed on it that I made a few
Christmases ago.

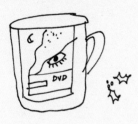

Bright turquoise cup, bought in a
charity shop in Crouch End in 2005,
when I had just left university
and everything felt exciting.

Colour looks great against
really orange builder's tea.

Psychedelic lizard mug
and matching coaster
from Aunt Sandra.

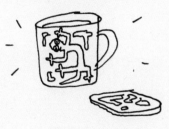

The style seemed unlike
her in a funny way.

MY FIRST

My first job was in a high street clothes shop. I can remember all the things that seemed so current: that little '2' in late-90s branding, slash-necked tops, Ted Baker T-shirts, Nokia 3210s, Peugeot 206 car keys.

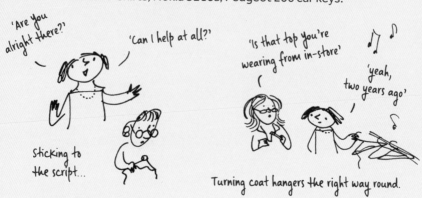

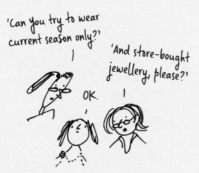

Paid £3.60 an hour, we had to spend our wages on clothes!

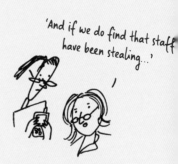

My bosses were accusing about stock takes.

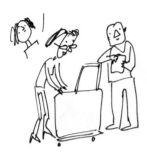

Unsold stock was taken away
and burnt. I never dared to
steal anything!

I got a different job at a shop round the corner.

Learnt how to fold
Ted Baker shirts really well.

'Look at you, posing
in this dump!'

My friends would come and chat. It's true,
I did enjoy posing behind that glass counter.

This exercise should present you with lots of
material. You could write about your first anything.
You could create a narrative or jot down disparate
moments. As you rebuild the scene, you'll remember
other things. How do you feel about it all now?

OVERTHINKING

Writing comics stops me anxiously ruminating. Turning those thoughts into something else – 'getting them out' on paper, really does help. And it's often funny to look back at them. I know there are far more important things to worry about, but somehow it's these moments that stick. **Write a strip about spiralling thoughts and see where it goes.**

THINGS I THINK ABOUT WHEN I'M STROKING THE CAT.

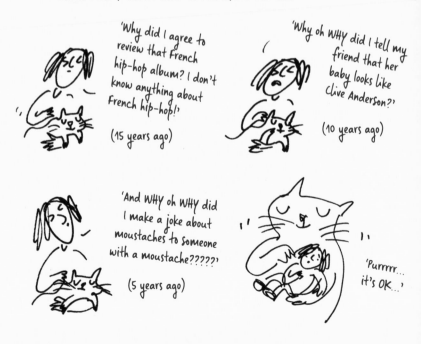

'Why did I agree to review that French hip-hop album? I don't know anything about French hip-hop!'

(15 years ago)

'Why oh WHY did I tell my friend that her baby looks like Clive Anderson?'

(10 years ago)

'And WHY oh WHY did I make a joke about moustaches to someone with a moustache?????'

(5 years ago)

'Purrrrr... it's OK...'

INTERNATIONAL WOMEN'S DAY

Making a list of inspirational women to share online.

Loads of illustrators, animators and comics artists, plenty of writers, artists in general...

'What about women who inspire me for reasons other than their creative output?'

'Can't really categorise them as 'other' or 'miscellaneous''

'What about all those great people who don't identify as women or men?'

'What even is it, to be inspiring? Taking risks? Helping people? Helping the planet? Having integrity?'

'UGH! I sound like an automated jargon machine!'

'And why should women feel like the need to be "inspiring" anyway?! I hate this!'

IN THE BATH OR SHOWER

I was looking at two paintings recently, 'Model Seated in a Chair, Combing Her Hair' by Vuillard, and 'Woman Combing Her Hair' by Degas. In both scenes, women are positioned uncomfortably: one with her arms held above her head to reveal her neck (Vuillard), the other twisted unnaturally to show a cascade of long hair and the profile of a breast (Degas). The museum caption said something pithy about 'self-care'. These strained poses made me want to draw self-care/bathroom sequences of my own, minus the male gaze.

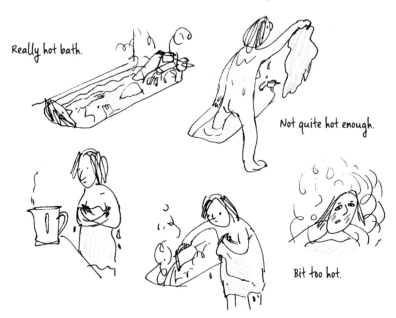

Really hot bath.

Not quite hot enough.

Bit too hot.

Got a fancy new 'haircare system'.

Meant to make my hair
thick and lustrous.

Totally stinks!
Making my eyes water.

Wash it all off again.

Write strips about your daily rituals. In what order do
you do things? Which products do you like to use?
Do you find baths relaxing or do you prefer to shower?
What do you think about? Vuillard and Degas' models
(and me) are below.

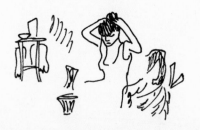

IN THE EVENING

If I have an idea for a strip, I draw it in the evening, feeling time passing as the light fades while I'm doing something I enjoy. Once you get into the habit of making diary comics, you'll start to notice things throughout the day that you want to write about. If I'm not working, I lie around scrolling on my phone until my hands seize up. Or read! Sometimes I read.

What are evenings like for you? Write strips about your routines and habits. Are you the sort of person who can't sleep unless everything on the draining board is put away? Or do you conk out on the sofa with the remains of dinner still on the table? What do you watch, read, do? How easy is it to relax?

I love making comics by the window while it gets dark outside.

Keep drawing until I can't really see.

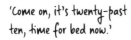

'Come on, it's twenty-past ten, time for bed now.'

'You were up late yesterday, so you need an early night.'

'Mummy, the past is in the past.'

'When it happens, you can just forget about it.

'Don't keep thinking about it for the rest of your life.'

(Good advice!)

'Life, living, memories... that's what it's called.'

'Alright, but you still need to go to bed.'

THE WORLD AROUND YOU

Look outwards, at people and everyday life. Use it as an excuse to visit places that you want to write about, anywhere you think that there will be characters or scenes that you'd like to observe. Even if you don't go anywhere new, people in familiar locations will still be interesting. Or write about the journeys that you make, and how different surroundings affect you.

OVERHEARD PORTRAITS

I loved listening to these teenagers chatting on the
train, the way their conversation jumped from subject
to subject, going off on tangents all the time. In
the first frame of this strip, one of the girls seemed
envious of the friend that they were talking about, so
I drew her with her eyes closed to show that she was
less enthusiastic than the others.

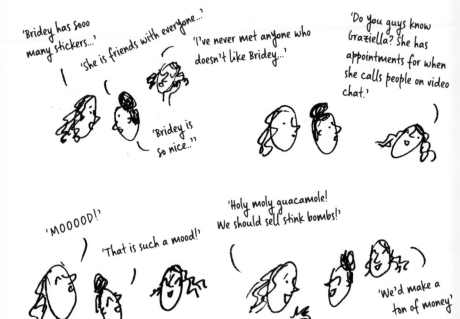

* names have been changed

Go somewhere you can comfortably listen to people talking. On a bus or train, in a cafe, gym, park or shopping centre. Try to really listen to the way that people speak, how they falter and interrupt each other, the common turns of phrase that they use. What stands out to you about them? How do you think they feel about each other? Think about how to get this across in your drawings. If the people in your comics aren't doing much, just sitting and chatting, you could just draw their faces and leave out the rest of their bodies, like I have done in this strip.

OTHER PEOPLE'S CLOTHES

These trendy parents at a playground were still dressed with such precision even though it was raining and the whole place was a mudbath. The angry dad's angles seemed to match the sharpness of his pointless instruction.

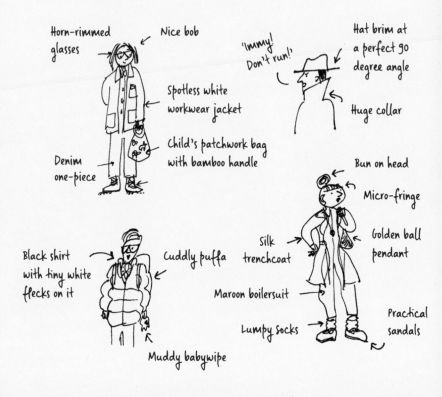

Horn-rimmed glasses

Nice bob

'Immy! Don't run!'

Hat brim at a perfect 90 degree angle

Spotless white workwear jacket

Huge collar

Child's patchwork bag with bamboo handle

Denim one-piece

Bun on head

Micro-fringe

Silk trenchcoat

Golden ball pendant

Black shirt with tiny white flecks on it

Cuddly puffa

Maroon boilersuit

Lumpy socks

Practical sandals

Muddy babywipe

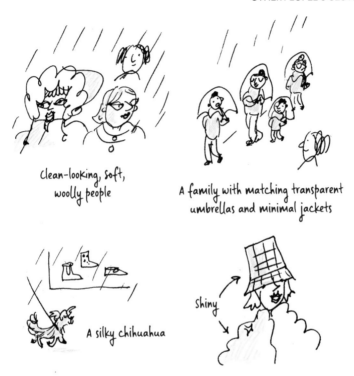

Clean-looking, soft, woolly people

A family with matching transparent umbrellas and minimal jackets

A silky chihuahua

shiny

Make these next strips about interesting outfits that you notice. They don't have to have a narrative. Think about how people use clothes to express themselves. What do you think each person wants us to understand about them? Which items do you see most often? When you are describing each outfit, consider which adjectives seem to fit. Above, are drawings of people on King's Road in London; they were soft, clean, woolly, silky, shiny and expensive.

FILMS, TV, BOOKS

Write comic versions of scenes from films or TV shows
you have watched, or books you have read. Or write
about how you reacted to watching or reading them.
It doesn't have to be a review or critical analysis – just
record parts that stick in your mind. I enjoy drawing
sketches of famous actors, and trying to sum up their
faces with just a few lines: their eyebrows, how they
hold their mouths, period hairstyles.

'It's like the tide going out, you can't stop it...'

Went to see the film 'Little Women'
(Beth accepting she's about to die)

'I will not be the person that you settle for...'

(Amy loving Laurie but
telling him 'NO')

'I am sick of
being told that
love is all women
are fit for...'

(Jo's loneliness)

Really good, cried the whole time.

Atmospheric French film
about two women in love

'A painter and her muse, fantastic!'

This little guy
knew more about
being human than
I ever will...

Blockbuster movie about an
anthropomorphic hedgehog

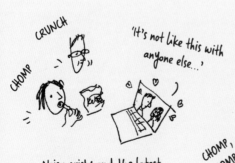

CRUNCH

CHOMP

'It's not like this with
anyone else...'

MUNCH
CRUNCH

CHOMP,
CHOMP,
CHOMP,

Noisy crisps and the latest
popular romance drama

IN THE PARK

Parks are so wonderful because they exist to provide the public with a space to relax. I love seeing how people interact with each other in this environment: socialising, catching up, exercising, resting, getting on well, arguing, celebrating or spending time alone.

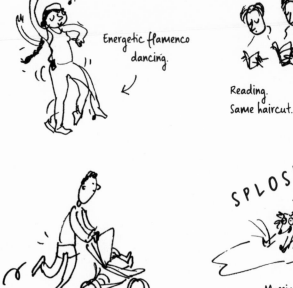

Energetic flamenco dancing.

Reading.
Same haircut.

Tiny-shorts dad.

SPLOSH!

Massive dog enjoying
a massive puddle.

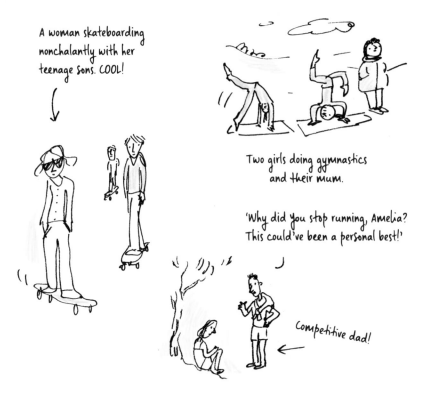

A woman skateboarding nonchalantly with her teenage sons. COOL!

Two girls doing gymnastics and their mum.

'Why did you stop running, Amelia? This could've been a personal best!'

Competitive dad!

Go to a park and people-watch. You could make several visits to parks in different areas, and notice the contrast in the characters that you see. I felt sorry for Amelia – it was a boiling hot day and she just wanted to sit down. To get the positions of the figures right, I looked up pictures of people doing flamenco and skateboarding because I couldn't remember what that looked like in real life.

MINDFUL LISTENING

I drew this first comic in the middle of a heatwave. I felt worried that it was hotter than ever, and anxious about climate collapse. The sounds of city life, continuing despite it all, were a comforting distraction. Even the hammering sounded alright.

Make some strips about what you can hear. How many different sounds can you pick out? Are they pleasant or annoying? How do they make you feel? You could write about sounds that really wind you up. Or you could describe familiar noises, like the reassuring creaks that your house makes. I once had a freezer that made a constant and gentle 'whoosh' like a desert wind on a distant planet.

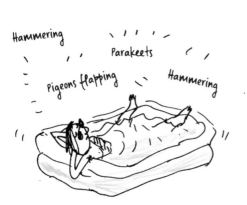

Mindful listening in the paddling pool.

Yesssssssss.

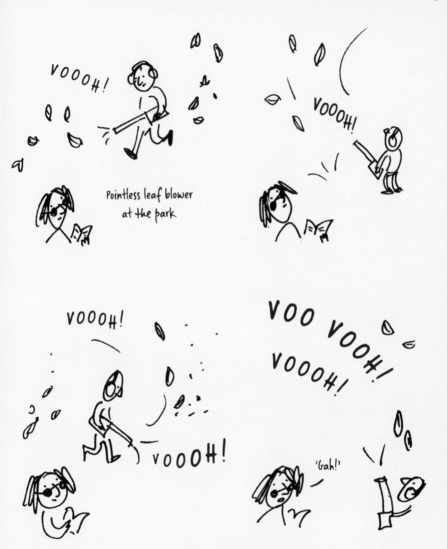

Pointless leaf blower at the park.

PASSERS-BY

I was really pleased with this drawing of the man sniffing, the way he looked so serious and then so gross. I also love remembering this joke a newsagent made with me when I was buying a chocolate bar.

Write about interactions you have with strangers, or interesting people. You can save these characters and use them again in a different story.

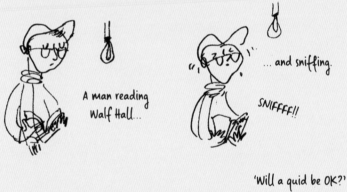

A man reading Walf Hall...

... and sniffing.

SNIFFFF!!

'Ninety-million pounds, please.'

'Will a quid be OK?'

'It'll have to do.'

Men with undercuts, vaping under a purple gazebo. What are they waiting for?

Strands of hair blowing across her face.

Pretty woman with a ginormous square handbag.

'ROXAAAANNE!!!!'

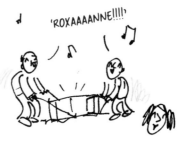

Two workmen moving a cast-iron bin and singing 'Roxanne' by Sting.

THE ENVIRONMENT

Government inaction on climate change, and individual denial, make me want to scream. Instead, I write comics. Taking something serious and framing it in a funny way can help people engage with uncomfortable truths. **What conversations have you had on this subject? Were there any global events, cultural moments, TV programmes that prompted you to think about it? Wildfires, melting ice caps, methane burps?**

'Humans will find a way. We'll invent technology to cope with it.'

'We need to change NOW! That technology hasn't been invented yet.'

'And none of these protester types ever have any plan for the future? What's their suggestion?'

'It's not their job to know. Their job is to persuade our governments to act on the climate emergency!'

'Society is complex. We can't expect changes overnight.'

'Actually, it's simple. Reduce emissions now and survive, or keep going and face extinction.'

Cheers.

Sat in the paddling pool.

Thinking about how it's 45 degrees in the Arctic Circle at the moment.

THAT'S HOTTER THAN EVER. THE FLIPPING ARCTIC IS ON FIRE!

WE CAN'T IGNORE IT ANY MORE. WE'RE BEING TOO POLITE!

ARRRRGH!

SQUIRT

A BIKE RIDE OR WALK

Write about the things you see, the places, people, and nature that you pass. Are you on a familiar route or going somewhere new? You don't need to say too much about each thing if you don't want to. Short observations, put together, will give a good sense of a journey.

If you aren't able to go for a bike ride or walk, think about where you would like to go and make your way there in your mind. You could travel virtually using Google Street View, and draw landscapes or streets anywhere in the world.

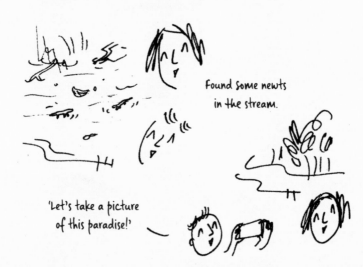

Found some newts in the stream.

'Let's take a picture of this paradise!'

Went for a bike ride...

Quite a lot of people about.

Listen to the
sound of my tyres
on the concrete.

Along the canal,
beautiful!

Feels like my boundaries
have expanded a bit.

And my armpits
smell great!

CAFES

Go and listen to people chatting in cafes. What do their conversations tell you about life and society? The girl on the laptop reveals the nepotism of the media industry. The guy with the statement hat and facial hair still has to do something ordinary like grapple with a rucksack. His joke about toilets was the last thing that people eating their lunch wanted to hear.

'I can't eat this soup! It's too hot!'

'We need a production assistant, do any of your friends have creative children?'

'Hey man, how's things?'

'Same old crap, different toilet.'

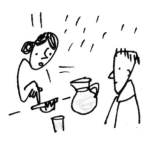

'It doesn't even say it's raining.'

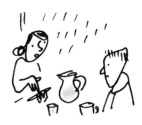

'It's totally raining.'

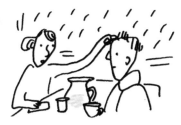

'You've got some fluff.'

'Hey, I needed that!'

Or this couple out for breakfast: the way the girl removes fluff from the guy's head without warning is a sort of public display of ownership. His response, a familiar joke, to show that he doesn't really mind. Notice the dynamics between the people you observe, and their body language. Are they comfortable? Showing off? Does one invade the other's space or interrupt? Do they speak in complete sentences? Are there any pauses or awkward silences? You can draw those, too.

DAY TRIP

I love going to the beach close to where I grew up. Not much has changed in 30 years and the same things still seem magical: jumping down shingle banks, poking around rock pools, sitting on the sea wall with an ice cream or a cup of tea.

Write about a visit to a familiar place. Why do you return to this location? Or go somewhere new. Did you find what you expected or were looking for? We changed our minds about visiting the Tower of London because we couldn't face explaining torture instruments to a six-year-old, and went for a walk instead.

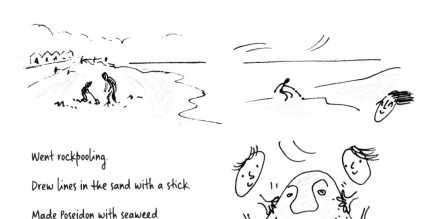

Went rockpooling.

Drew lines in the sand with a stick.

Made Poseidon with seaweed and stones.

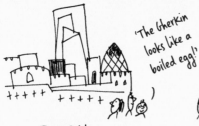

'The Gherkin looks like a boiled egg!'

Tower Bridge.

Pass some luxury restaurant podules.

Interesting snapshots of family dining experiences. Thick sheepskin rugs and a baby with a bow on its head.

Cashmere off-the-shoulder jumpers and full glasses of prosecco.

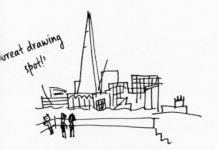

Great drawing spot!

Sixties highwalks; walkways that don't go anywhere.

'Now I can see if my leg's at a 90-degree angle to the ground...'

Try out yoga moves in the reflections on office windows.

SMELLS

This strip is about a weird mixture of smells on a train journey. In the end, my face turns upside down in misery at the overpowering fug. Very strong perfumes smell awful when mixed with wafts of mayonnaise, disinfectant, mildewed coats and such like, and you don't always want to experience the scent of musk or lily of the valley when you're eating a burger – or at least I don't, anyway.

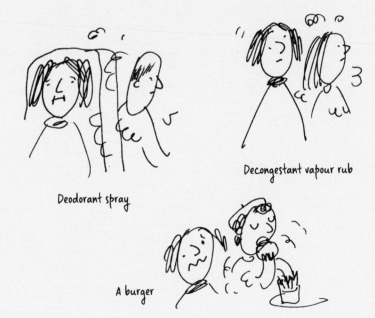

Deodorant spray

Decongestant vapour rub

A burger

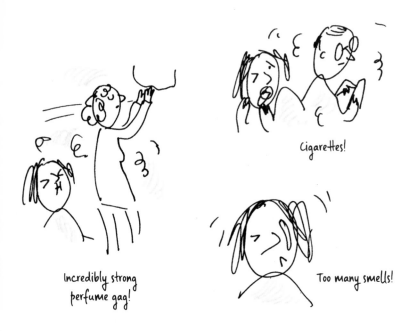

Incredibly strong
perfume gag!

Cigarettes!

Too many smells!

Think about smells you love or hate, besides the
obvious ones. If your childhood home had a smell,
what would it be? Some smells that I really like are
decaying leaves, my hands after I've been chopping
garlic, creosote, art studios and the sea.

WEATHER

Write strips about times when you were affected by weather. What were you doing? What clothes were you wearing? Were they comfortable or not? What else did you notice? Melty, sticky, smeary sun cream, or wasps in your orange juice? The biggest puddle ever? Think about what people look like in different conditions: hunching over to keep dry, hair blown flat in the wind, or floppy and slumped in the heat. What shapes do those figures make?

Which words would you use to describe elemental extremes? 'FOOM' seemed about right for Storm Ciara blowing rain into our sitting room.

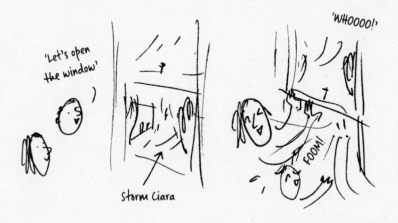

Storm Ciara

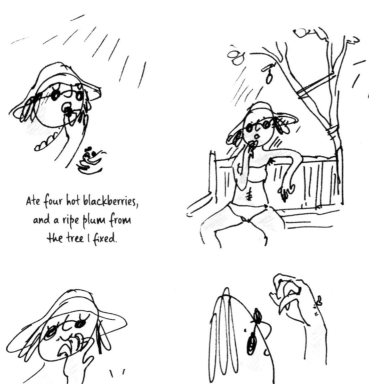

Ate four hot blackberries,
and a ripe plum from
the tree I fixed.

Juicy

Caterpillar on my hand!

I was really pleased with the drawing above, of
myself sitting under a plum tree on a hot day. I think
I managed to capture the relaxedness of my body,
even though my arms look a bit bendy and strange.
Almost eating that caterpillar shocked me out of
my heat-induced lethargy.

A WALK IN THE RAIN

Go for a walk in the rain and write comic strips about the experience. Trying to explain to my son the point of going for a walk, even though we weren't going anywhere, was both funny and fun. A lonely wet dog can be as interesting as a beautiful view if you are a committed psychogeographer (a person who enjoys drifting and noticing the effects that different environments have on their state of mind).

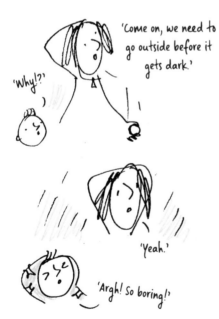

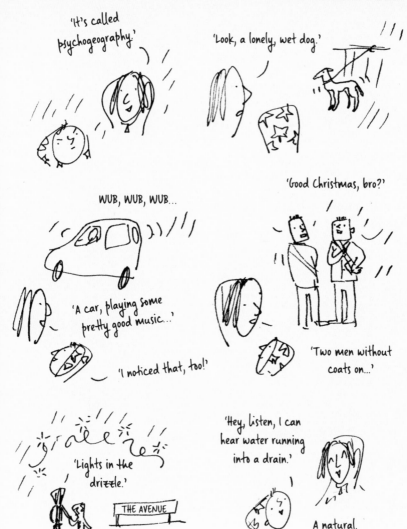

MODERN LIFE

Examine how modern life makes you feel: politics, the environment, online content, sudden changes to the way we all live. How do you navigate your existence and what do you want to say about it all?

THE NEWS / BEING POLITICAL

Writing comics about what's going on in the world, about politics, about society, is great way to learn about and understand those things. In order to condense a situation or idea it into a few frames, you need to be clear about what the key points or issues are, and what you want to say about them. I wrote this strip in response to the way the pandemic had been framed (in conversations about the environment) as a good thing for the planet.

Is there a particular subject that's important to you? Read and research before starting to write, use quotes from other sources if it's useful.

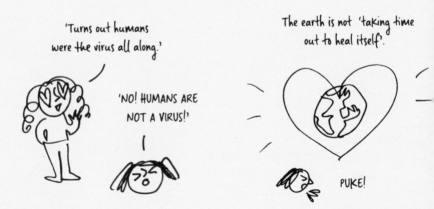

BUT, this is a global health crisis.
People are dying. There have been
mass lay offs. Hospitals are in chaos.
These aren't positive things.

Of course I am glad the air is clear,
and that there are fewer cars on the
roads because of lockdown.

'Silver lining?'

'NO!'

We don't need fewer people. That
idea is so dangerous. Who decides who
should or shouldn't be here?

There isn't some benevolent Mother
Earth, deciding whose life is worth
saving. Those are political choices.

'Protect the economy. If some
pensioners die, too bad.'

Personal stories can be political, too. Giving your
readers an insight into your life: what it's like at home
or at work, or how you identify, may inspire a shift in
thinking that helps to create positive social change.

A CHANGING WORLD

What conversations have you had about the challenges that we face in the 21st century? I had to find a way to talk about the Covid-19 pandemic that wasn't too frightening. I got sucked in by alarmist content, telling me to wash my shopping, then realized it was unsustainable and all a bit much.

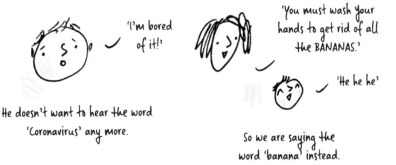

'I'm bored of it!'

He doesn't want to hear the word 'Coronavirus' any more.

'You must wash your hands to get rid of all the BANANAS.'

'He he he'

So we are saying the word 'banana' instead.

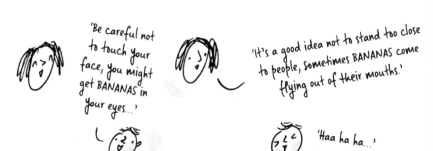

'Be careful not to touch your face, you might get BANANAS in your eyes...'

'It's a good idea not to stand too close to people, sometimes BANANAS come flying out of their mouths.'

'Haa ha ha...'

'If you can, leave it on the porch for three days...'

I fell for that video, telling people how to disinfect their groceries...

'The skin of a fruit is porous, like our own skin...'

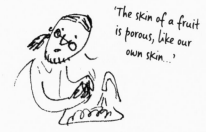

... washing fruit and veg with soap.

Tried doing it, but everything went everywhere and it seemed impossible.

'Did you wash those packets of glitter?'

'Er, yeah?'

'Do you mean, "no?"'

'Yeah.'

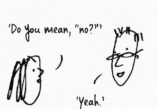

Will stick to handwashing.

POSITIVE MOMENTS

Keeping a record of moments that made you feel good is an enjoyable exercise. If you are feeling low, looking back and being reminded of things that seemed funny, or activities or interactions that you appreciated, can leave you feeling better. Thinking about something for long enough to write about or draw it is an effective distraction, too. Even if you feel fine to start with, it's still fun to do this!

Write strips about something that lifted your spirits. It could be simple or small, a conversation with a friend, the sun on your face, or wearing a pair of really comfortable shoes.

NEW CHAIR

DOWN

UP!

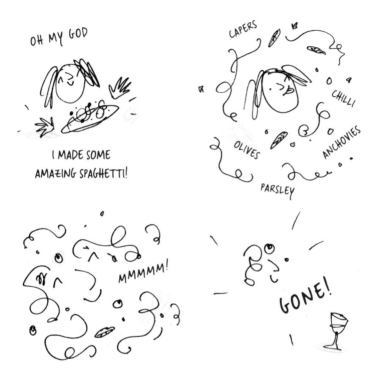

How will you express the mood of the moment? In this strip about making excellent spaghetti, I loved it so much that I drew myself dissolving into the plate, consuming myself with happiness.

THE ALGORITHM

Because I'm a woman in my late 30s, and have 'liked' too many pictures of beach huts and mid-century sideboards, I get a lot of adverts for outfits that are made of linen, in boring cuts and colours. Maybe I'd like to wear something made of plastic and covered in fairy lights instead.

In this advert, I thought that the slogan 'Meet our balloon jeans' could easily become a comic strip. The jeans would enjoy patronizing me for believing that I'm one step ahead of current trends, safe in the knowledge that I always want more trousers.

A clothing brand really want me to 'meet their balloon jeans'

'Look, mate, I've been wearing balloon jeans for years.'

I could change my app settings and opt out of ad personalisation, but I quite enjoy seeing all the weird stuff that pops up (it makes for good comics material). It's always when I'm looking for a recipe or cooking that I get the worst ones, photos of treatments for toe fungus or earwax.

Instead of ignoring your targeted ads, try taking screen grabs to draw from. What do you think the algorithm makes of you? How do you react to the identity it creates? Write a short strip about how the images make you feel. Do you think they are annoying, funny or bizarre?

INTERNET WORMHOLE

Do you find yourself awake at 3am reading about spontaneous human combustion, giant jellyfish or sink holes in Siberia? I love clicking on social media locations and seeing all the pictures of people who have tagged themselves in those places. The holiday poses that people make, when you see them all together, are very funny.

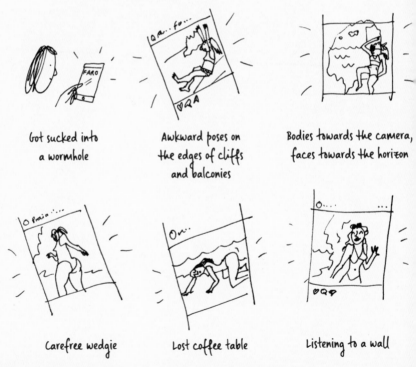

Got sucked into a wormhole

Awkward poses on the edges of cliffs and balconies

Bodies towards the camera, faces towards the horizon

Carefree wedgie

Lost coffee table

Listening to a wall

Another thing I get stuck looking at is 'before-and-after' tooth veneer pictures. Sometimes I think I'd like perfect teeth, then seeing rows of identical smiles seems unsettling and I change my mind. **Write short strips about the trains of thought that internet browsing inspires for you. What subjects are you drawn to?**

All the fixed teeth look
EXACTLY THE SAME!

Look at my crooked pegs.

I like them!

SOMETHING FUNNY

Write about things you thought were funny. You can exaggerate and make what happened seem funnier than it actually was. My too-tight glasses didn't really squeeze my head into that shape, but drawing that adds to the silliness. I didn't really run away from the woman selling chutney for £29.99, I sidled off awkwardly, but that wouldn't have worked so well in the strip. The tiny snail did in fact out-crawl the large snail in the slowest chase scene ever!

Snail problem in the fish tank.

Drop in a snail-eating snail.

'Come on, mate!'

Today, my pants were too tight and so were my glasses.

NIGHTMARE!

'How much is this chutney?'

'Twenty-nine ninety-nine madam.'

'Nope!'

'I might go for a morning walk!'

'Classic!'

Five minutes later.

FOOD

Food can tell us about life: the food we eat when we're celebrating, student food, hospital food, work lunches, or food from your childhood. Perhaps there's a type of food that you really dislike that inspires a story or memory. How does eating this thing make you feel? What about comfort food, or a dish prepared for you by someone else?

For a while, I had a veg bag delivered. It always contained too many Jerusalem artichokes, which would hang around looking sinister at the back of the fridge, slowly going off.

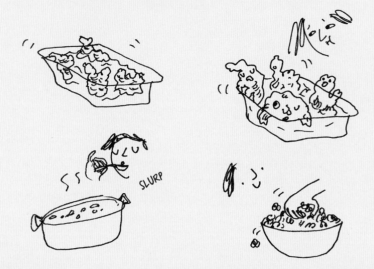

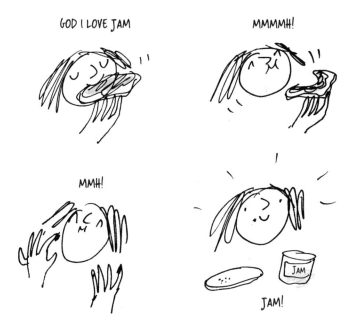

Write short strips about food or eating, and notice the expressions people make and actions they inadvertently perform when eating different things: a little finger stuck in the air when slurping from a teaspoon; an enthusiastic hand grappling in a bowl of popcorn, trying to get hold of as many pieces as possible; or an ecstatic 'mmmm!' with a mouthful of toast.

SHOPPING

I used to love shopping before it sunk in that consumer culture and over-consumption are destroying the planet. Fast fashion, make-up, gadgets, plastic toys . . . whatever it is, we need to buy less of it. With this in mind, trying to find things like children's birthday presents can be difficult. Boring wooden eco toys are particularly funny!

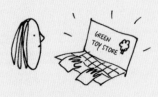

Trying to find plastic-free gifts for six-year-old boys.

Cardboard house with a solar-powered light inside it.

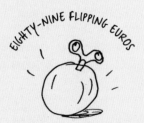

Spherical, wooden musical box.

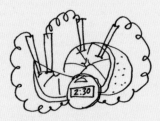

Bought five lemon-powered clocks, sorry, lads!

IT'S NOT
'BLUE MONDAY'!

IT'S JUST A DAY!

WHY IS THERE A CAMPAIGN
DESIGNED TO MAKE US ALL FEEL
WORSE THAN WE ALREADY DO?

I WILL BUY THOSE NORDIC SOCKS
AND HAVE A HOT CHOCOLATE
ON MY OWN TERMS!

LEAVE ME ALONE!
I FEEL FINE!!!

HONESTLY!

I wrote the strip above in response to a UK-wide PR campaign, 'Blue Monday', which happens on the third Monday in January, when we are all meant to feel terrible because it's not Christmas any more, we're back at work and the weather is still cold. The aim is to counter the gloom with chirpy ads while increasing brand awareness and selling us all more stuff. (It was inspired by 'Brew Monday', started by the Samaritans, to encourage people to check in with each other over a cup of tea – a very good idea.)

What is the latest thing that you have bought, felt tempted to buy, or enjoyed buying? Why did you want it? How did buying it/not buying it make you feel? You could write about advertising, about the shop where you saw a certain item, or about the item itself.

EXERCISE

I exercise to feel good and keep healthy, but I'm put off by any approach that implies that the way my body looks is not already perfectly fine. I'm not interested in doing anything that hurts!

Write about the way exercise features (or doesn't) in your life. Do you prefer low-impact activities or more strenuous sports? Do you exercise alone or for the social life? What do you think about while doing it?

I tipped my face upwards to try and stop my glasses sliding down my nose.

Nice!

Encouraged by a van.

'sweaty'

Bought a new yoga mat and now my targeted ads are completely deranged.

'Core sculpt is here! Burn like a mutha!!!!'

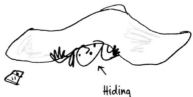

PLANT LIFE

Do you keep plants at home? How do you feel about them? Are they well looked after? I usually have a thirsty mint plant and some half-alive basil on my kitchen table, and a few other potted herbs at different stages of life/death outside my front door. If I do manage to care for a plant for longer than a few months, I feel proud.

I put three oxeye daisies in a blue glass vase.

Repotted a mint plant.

Added a rose to the ones I picked up yesterday.

The long-dead oregano is actually alive and sprouting two leaves.

I love seeing pictures of flower arrangements that people post online, and the different ways that they find to pose around those massive blooms.

Write short strips about plants in and around your home. If you don't have any, try looking online at the different trends: terrariums, cacti, succulents, ferns. The way people arrange their plants alongside ornaments or books, the light casting shadows of leaves onto the walls. What do they tell you about each person? Notice why you are drawn to particular plants, and what they make you think of.

Peony eclipse...

Can't say I wouldn't love my own giant bunch! (Saturn's moons)

MEMORABLE MOMENT

In the middle of the first coronavirus lockdown, I looked out of my window and saw a woman, alone in the empty street, smoking a cigarette and hopping and skipping on a hop-scotch grid left behind by some children. Combined with the stress of the situation and the smallness and vulnerability of the figure, the scene seemed to encapsulate something of the time that we were living through. Then, later, a good moment: a perfect egg.

A woman in the road, playing hopscotch and smoking a fag.

A perfect soft-boiled egg.

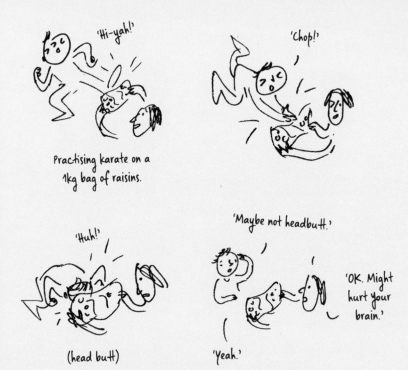

Your strips don't have to be deep, emotionally significant, or even positive. Just anything that grabs you, for whatever reason. It could be something that seemed strange or out of place, something that happens regularly, or something that made you laugh. A collection of vignettes like this will create a picture of life. The comic strip above is another from lockdown, looking for things to occupy a small boy.

SOMETHING ANNOYING

Make your next strips about an annoying or frustrating
situation. Maybe your neighbours started doing
loud DIY, or playing music that you absolutely hate.
Perhaps you had an awful haircut. Or did you put on
a favourite outfit then drop sauce on it? What about
things that are meant to be fun but aren't? Like kites
– the idea of them is so lovely and uplifting, but the
reality…?

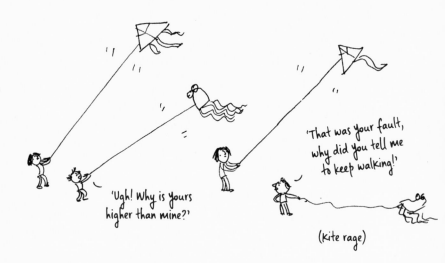

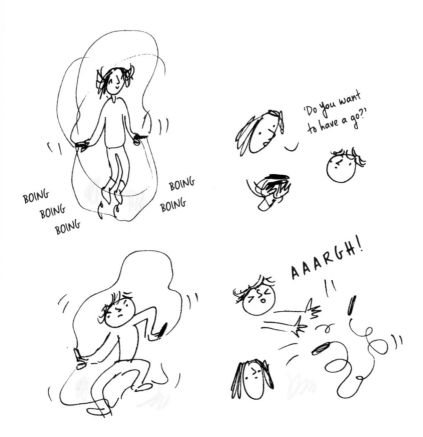

All these things have comic value, although they are enraging to experience. How did you react? Are you easily irritated or more likely to let things go? You could write about something much bigger or more significant. What really winds you up?

A TIME I FELT

The comic opposite shows the moment my son broke down, thinking he'd lost everything he'd made on Minecraft (a computer game where you build a world for yourself). I felt like crying too, because he'd been locked down at home for almost a year, and what he and other children had actually lost was a year of real life. His sadness at this virtual loss, but acceptance of our reality, seemed poignant.

Write about a time you felt a strong emotion. You could show your reaction, or leave it out and describe the event or situation that made you feel that way.

'I tried to download something onto Minecraft, but when I went back to all the stuff I was making...'

'It has disappeared... I don't think I pressed 'save' and now it's all gone...'

'All my things, my chickens, my art gallery, all that hard work for nothing...'

'Yes! There! It's back!'

'Oh no, maybe Dad can fix it...'

'Is this it, here?'

'Thank God!'

'I was thinking I might add a shed to my house and a metal door to my armour room...'

'For a moment there I thought I'd lost an entire world...'

MORPHS

One of the wonderful things about comics is that
you can create your own logic for the strips. Even if
you are writing a diary about your life, your drawings
don't have to be naturalistic or 'real'. When I work at
home, sitting still at my desk, I start to feel like the
pieces of furniture in my house. Making this strip, I
enjoyed looking at the different physical attributes
that each thing has, and deciding which bit would best
suit being anthropomorphized: the throw tucked into
the sofa that looks like a hand, and the lampshade that
becomes a head.

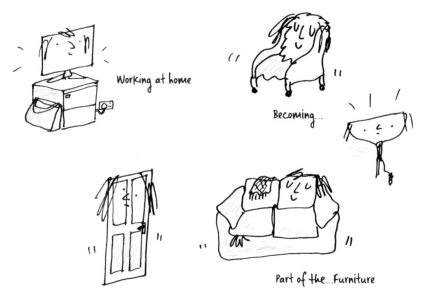

Working at home

Becoming...

Part of the...Furniture

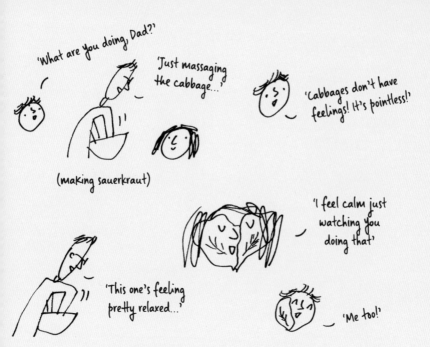

Draw strips in which one thing morphs into the form of another. It could be you morphing into the shape of something else, or you could choose an object to transform. Think of a reason for why it might change shape. What would you say if you were that thing? This can be as weird as you like. If you can't think of a reason or idea, just draw any object to start with – an alien, a pineapple, a mushroom cloud – and think about why you might like to change if you were that thing.

FAMILY & FRIENDS

Look at the people in your life and how you spend time together. Write about those with whom you feel most comfortable. Or about the different versions of yourself, your at-work or online persona, and the relationships you have with your family and friends.

SOCIALIZING

Write strips about your social life. It could be a time you remember fondly or a typical occasion for you. How have you kept in touch with people over the past year or two? I found it moving to see my son and his friends having play-dates over Zoom. The things they chatted about were so sweet.

Go for Vietnamese food.

Play table football.

Think, 'wow, I'm really quite good at this!'

Then Paul thrashes us all!

CONVERSATIONS AT WORK

I used to work with a guy who would always talk about disgusting subjects at lunch time. He couldn't not do it. Roadkill, diarrhoea, infected wounds, things like that. In the scene shown here (at a different workplace), the ketchup on my chips seemed to fit with the gory anecdotes.

'Sat on a fork!'

INJURIES DISCUSSED OVER
LUNCH AT WORK TODAY

'Fish hook in my toe!'

'Dart in my heel...'

Write about memorable conversations that you had or overheard in an employment setting. If you work at home or don't have a job, write about conversations that you witnessed at other people's places of work. What are the go-to topics? How does the way people interact change when they are working? In a doctors' waiting room, recently, two receptionists had a long chat about green-tea-flavoured Kit Kats. It was much nicer listening to them than to the information videos about depression and heart disease.

ANIMALS

If you have a pet, do you speak to them as if they are
a person? Do you give them a voice? If so, what do
you talk about together? What do you think
your pet makes of you? If there are other people
in your family, do you speak to each other through
your pet? I haven't given my cat a voice – I get the
feeling he wouldn't approve, as if I couldn't possibly
appreciate the depth of his thoughts – but I do speak
(in my head) to snails and slugs when I'm in the garden.

A snail has been eating
my baby squash plant.

'You!'

'Well I hope you're happy...'

It does look
happy. Good!

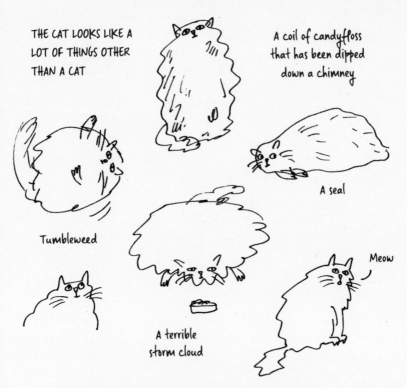

THE CAT LOOKS LIKE A LOT OF THINGS OTHER THAN A CAT

A coil of candyfloss that has been dipped down a chimney

A seal

Tumbleweed

A terrible storm cloud

Meow

Draw short strips about an animal or animals. If you don't have a pet, watch the birds outside your window, dogs at the park or neighbourhood cats. How do they behave? What do they remind you of? What are their funniest quirks? Do they have human-like qualities? My cat isn't really cat-shaped, he's just a fluffy ball with ears and whiskers, which makes him fun and easy to draw.

SOMEONE I LOVE

Think about the people you really love or admire. Friends, family, or people you haven't met but who feel important. The things that you love about them could be small and ordinary or more significant. What do they do that no one else does? You could write about moments that you have shared together. Did they say something funny that you'd like to remember? Or you could write about a public figure or celebrity, someone who has made an impact on you in some way.

MMMM...

...WAH!

Goodnight Kiss

'The thing about kisses is that you go "mmm", and you never know when the other person is going to go "WAH!"'

'But why are kisses so nice?'

'I guess because you are feeling love for the other person?'

'yeah, guess so.'

Enjoying the cosiest
corners of the flat.

Working, perched on the end
of our son's cabin bed, when
sun shines into the room.

By the window and
radiator on rainy days.

A bit like a cat.

SOMEONE I MISS

This strip shows the last time my dad and I took my grandfather for a walk around his garden, before he died. Sometimes it feels right to allow your reader to imagine a feeling without needing to see it: in the drawing where I'm on the phone, I think it works better to show the back of my head, rather than my expression. Emptiness or silence can be meaningful, too, like in the last image.

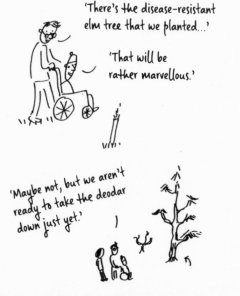

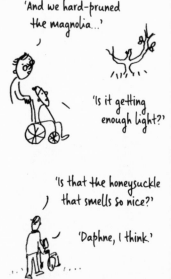

'I thought I said goodbye to you last week...'

The love in his funny remarks.

The warmth of his hands.

'The problem with people being so wonderful is that you miss them so much when they go...'

'Yes, I love you too...'

Think about the people that you really miss. People you would love to see again. What do you remember most about them? Maybe it's the sound of their voice, the way they laugh, the smell of the washing powder they used, or the things you did together. These strips don't have to have any kind of story, they could just be disparate moments. When working out how to draw or describe a person, you may feel close to them again.

HOBBIES & INTERESTS

Write strips about your hobbies and interests. Or write about the enthusiasts in your life. What do they like? Mosaics? Crochet? Botany? Renaissance polyphony? Spoon whittling? Jigsaws? Golf? What experiences or conversations have you had with them, around these things?

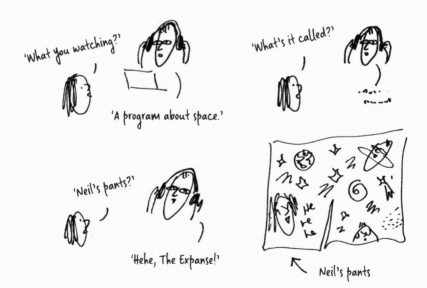

'What you watching?'

'A program about space.'

'What's it called?'

'Neil's pants?'

'Hehe, The Expanse!'

Neil's pants

'Blah blah magic eggs, fire signs...'

Nattering about his favourite animated series.

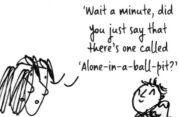

'Wait a minute, did you just say that there's one called 'Alone-in-a-ball-pit?'

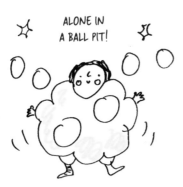

ALONE IN A BALL PIT!

'No, Mum! You always get it wrong!!'

'Felafel?! Why would you even think of that!!'

There seem to be others called 'Felafel' and 'Tri-fold'.

DISAGREEMENTS

Sometimes arguments can be funny, like this one about a haircut. **Write a strip about a disagreement you had with someone, or one that you imagine having. Were you / would you be able to resolve the situation or not? If so, how? If you are the kind of person who likes to avoid conflict, what do you keep bottled up? Is there anyone you would really like to take to task about something? A politician or public figure? A teacher, relative or friend?**

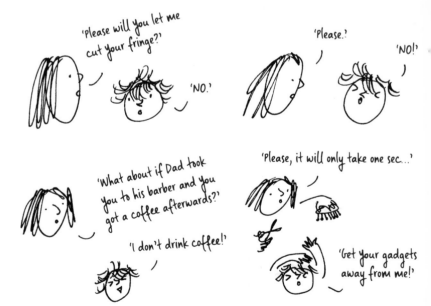

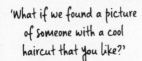

A DIFFERENT GENERATION

Here's what I think is funny about this conversation that I had with a friend's teenage son. I thought he would be stunned to find that I had once been a DJ too; I imagined he would be DJing at small university bars, not clubs in Ibiza and Dubai. I tried to impress him by talking about warehouse parties, and felt like a dissolving skeleton.

Have a conversation with someone of a different generation to you. Someone older or younger. What do you understand or misunderstand about each other's lives? Talk about anything – cooking, music, something on TV, whatever they happen to be doing.

'Oh, yes? What do you play?'

'Erm, kind of electronic? Tech house?'

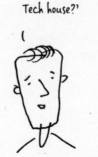

'COOL! I used to be a DJ myself, once...'

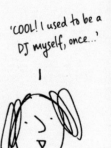

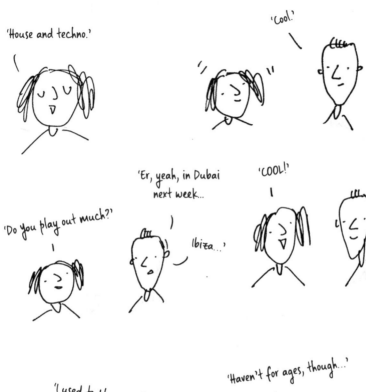

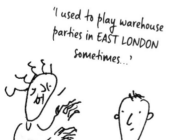

GAMES

I love the awkwardness of charades, the chaos of table football, and the meditative nature of a simple game of catch. **Write strips about games you have played. They could be computer games, or any others that you play online. Are there games that you've invented with family or friends that no one else would get? How do players interact or speak to each other when they are playing? It's always interesting to observe social dynamics and competitive characters.**

'Ha ha ha!'

Allow a game that involves chucking a ball at the back on my head.

'Wait, this is weird, why don't we just throw the ball to each other instead?'

'OK, Mummy.'

Playing 'foot box'.

'Wagh!'

'Goal!'

CHARADES

CHRISTMAS

Apart from the pressure to buy loads of stuff that we don't need, I love Christmas. Special food, decorations, familiar rituals, twinkly lights, carols, games, all of it. I'm not religious but it seems right to have a festival that broadly celebrates togetherness and new life in the coldest, darkest months of the year.

What is Christmas like for you? Are there family rituals or objects that appear every year that you could write about? What's the atmosphere like? Who does the cooking? What's expected on Christmas Day?

CHRISTMAS QUIZ

'Lincolnshire Poacher!'

'Which type of hard cheese does Nanny find least intolerable?'

'Which type of bun did Emma sniff at Mary's Crumb Pantry in 1965?'

'Rock cake! Iced finger!'

PLAYING 'COSTUME CONSEQUENCES'

A REALLY GREAT DAY

Enough snow fell recently to go sledging, which I hadn't done since I was about 14. Flying down the hill, snowflakes blowing into my face, I thought about how exhilarating it was to be that age, out discovering life with my friends. It was wonderful to be transported back there, while enjoying the present moment at the same time.

Write about a day that you really enjoyed. It could be that you did something unusual, or just an ordinary day that made you feel good.

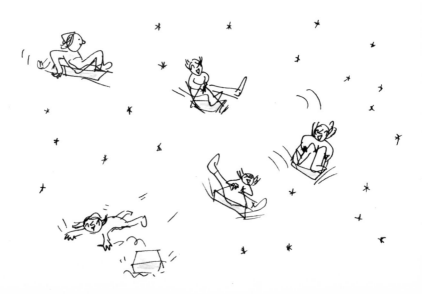

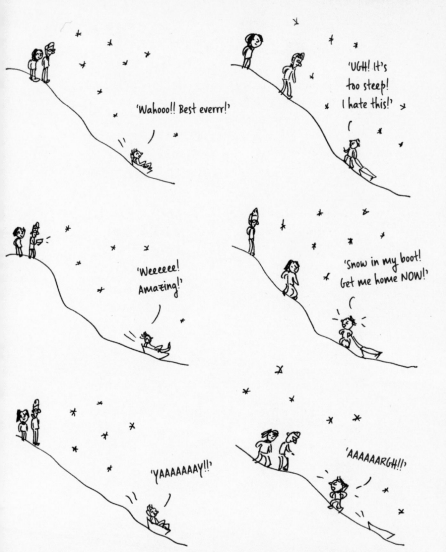

WRITING ABOUT WRITING

What has the process of making diary comics been like for you? Are there any subjects that you really enjoyed writing about? Have you noticed your writing or drawing style changing at all? Have you shown your comics to anyone? How did they react? How did you feel about sharing them? Where will you go from here? Write strips about your writing process. I hope it has been fun!

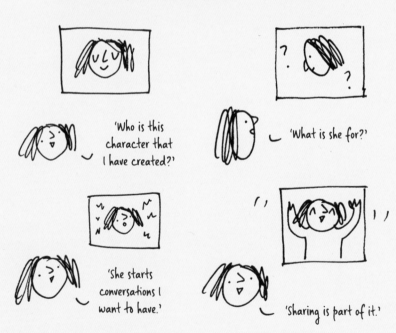

'Who is this character that I have created?'

'What is she for?'

'She starts conversations I want to have.'

'Sharing is part of it.'

'He he! I'm happy, then angry, then happy, then angry again...'

'The comics are always funnier than in real life!'

'Yes, it wasn't very funny when you were having a bad time.'

'But it's funny here, ARGH! YAY! ARGH! YAY!'

'Do you mind that I make those things seem funny?'

'No. I like it.'

'It's a nice way to remember, isn't it.'

'Yeah!'

'The next one hasn't got any words.'

'Still quite funny though!'

FURTHER READING

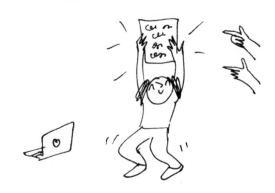

WEBSITES

graphicmedicine.org
A website and resource for comics about illness and
healthcare. Authored by patients, healthcare workers,
carers and people who have experienced illness.

positivenegatives.org
A not-for-profit group producing comics about
international human rights and social issues, conflict,
migration and asylum.

LDComics.com
The largest women-led comics forum in the UK, open to all.

COMIC ARTISTS ON INSTAGRAM

@_coronadiary, @aishathesheriff, @Avocado_Ibuprofen, @beckybarnicomics, @bedwyr_williams, @biancaxunise, @breakdownpress, @breenache, @brokenfrontier, @candyguard, @carsonellis, @crayonlegs, @dortyparker, @edithcartoonist, @ellistrate, @emilykmcullen, @floperrydraws, @fml.comics, @gemmacorrell, @goodtalkthanks, @hennybeaumontillustration, @hollycasio, @isabel_greenberg, @JacobVJoyce, @jilliantamaki, @jill_gibbon, @joedecie, @joaaaosobral, @kayeblegvad, @karllikesotto, @lisadraws, @lizzy_stewart, @loutheodore, @maria_stoian, @michi.mathias, @monachalabi, @mr_zeel, @nebelerik, @nicolast.reeten, @nievesbooks, @noiamreiss, @olivehide, @orson_cortoon, @opandagordo, @paulajkstudio, @philipparice, @rapturebird, @rachaellhouse, @Rob_Bidder, @rosafisher_, @rozchast, @rudyloewe, @sarahmirk, @shortbox_comic, @sofia_niazi, @spillsey, @takayo_aki, @tarabooth, @thebaddr, @thebookofsarahlightman, @thefakepan, @thegreatescapist, @therickardsisters, @tilliewalden, @tormalore, @walliseates, @julesscheeleillustration,

Instagram: @MatildaTr
www.matildatristram.com

Graphic memoir about cancer and pregnancy:
Probably Nothing (Penguin/Viking 2014)

Thank you to Monica at Quarto, for sticking with me while this idea developed, and for all your encouragement and insight. Also to my brilliant editors, Charlotte, Chloe and Rachel, for knowing what I mean, and to the design team for bringing it all together, and for being patient with my hesitancy over hand-drawn type faces. Thanks to my animation and illustration students – I love the comics that you make! Thanks to my agent, Becky, for sorting everything out, I really appreciate it. Most of all, thanks to my family and to Tom and James, for not minding that I write about our life, and for being so funny and inspiring.